a bony framework
for
the tangible universe

d. allen

the operating system KIN(D)* print//document

a bony framework for the tangible universe

ISBN: 978-1-946031-46-4
Library of Congress Control Number: 2019901273
copyright © 2019 by D. Allen
edited and designed by ELÆ [Lynne DeSilva-Johnson]

Books from The Operating System are distributed to the trade by SPD/Small Press Distribution and Ingram, with additional print production by Spencer Printing, in Honesdale, PA, in the USA.

This text was set in Zebrra, Europa, Minion, Franchise, and OCR-A Standard.

Cover art uses an image from "Thorns," a collaboration between D. Allen, Hannah Sabri Barco, & Andrew Barco. Durham, NC, 2006. Cover design by ELÆ.

[Cover Image Description: Warm color photograph of the poet's torso with thorns adhered to vertebrae with wax, against a dark background. Front and back covers are mirror images of each other; on front cover, transparent text(ure) is layered over the image, with the book title and author's name; on back cover, two blurbs are layered over the poet's torso.]

the operating system
www.theoperatingsystem.org
mailto: operator@theoperatingsystem.org

a bony framework
for
the tangible
universe

2019 OS SYSTEM OPERATORS

CREATIVE DIRECTOR/FOUNDER/MANAGING EDITOR: ELÆ [Lynne DeSilva-Johnson]
DEPUTY EDITOR: Peter Milne Greiner
CONTRIBUTING EDITOR, EXPERIMENTAL SPECULATIVE POETICS: Kenning JP Garcia
CONTRIBUTING EDITOR, FIELD NOTES: Adrian Silbernagel
CONTRIBUTING EDITOR, IN CORPORE SANO: Amanda Glassman
CONTRIBUTING EDITOR, GLOSSARIUM: Ashkan Eslami Fard
CONTRIBUTING EDITOR, GLOSSARIUM / RESOURCE COORDINATOR: Bahaar Ahsan
JOURNEYHUMAN / SYSTEMS APPRENTICE: Anna Winham
DIGITAL CHAPBOOKS / POETRY MONTH COORDINATOR: Robert Balun
TYPOGRAPHY WRANGLER / DEVELOPMENT COORDINATOR: Zoe Guttenplan
DESIGN ASSISTANTS: Lori Anderson Moseman, Orchid Tierney, Michael Flatt
SOCIAL SYSTEMS / HEALING TECH: Curtis Emery
VOLUNTEERS and/or ADVISORS: Adra Raine, Alexis Quinlan, Clarinda McLow, Bill Considine, Careen Shannon, Joanna C. Valente, L. Ann Wheeler, Jacq Greyja, Erick Sáenz, Knar Gavin, Joe Cogen

The Operating System is a member of the **Radical Open Access Collective**, a community of scholar-led, not-for-profit presses, journals and other open access projects. Now consisting of 40 members, we promote a progressive vision for open publishing in the humanities and social sciences.

Learn more at: http://radicaloa.disruptivemedia.org.uk/about/

Your donation makes our publications, platform and programs possible! We <3 You.
http://theoperatingsystem.org/subscribe-join

for you, my beloveds, and for our beloved troubled bodies

I tried to put together a text at the same time that I tried to put together my body.

—Eleni Stecopoulos, *Visceral Poetics*

||contents||

As a multidisciplinary, process-oriented poet who is part of many creative ecosystems, I must honor the sources, materials, relationships, and methods that allowed the creation of this book. Rather than disrupt the flow of the manuscript with footnotes or epigraphs, I compiled the Process Notes & Ephemera on p. 125-31. This is not an afterthought but a vital part of the project, and I encourage you to refer to it as you read each piece, or to read it at any point as its own text.

[one]

[if i describe the pain as a barrier to love]

—if *I don't have hands today*
means I can't use them to touch you—

what, then, could we call my index finger
when it slips inside your flannel shirt collar

traces your twice-tattooed collarbone

 faded ink striped with late morning light

you have learned to read my pain level
by the temperature of my hands
today they are stone altars

a hundred candles
blush and flicker

 unequivocally alive

you reach for me
a smokeless heat rises

The hand is a machine designed for controlled grasping :

(Outside the window, a construction crew raises lumber
onto the neighbor's roof. Shouts—the pulley breaks—
wood clatters onto concrete.)

The hand flexes and furls to bring our desires nearer :

(Your shirt buttons roll like seeds just out of my reach.
I relinquish to you the task of your own undressing.)

The hand's many hinges allow for strength and dexterity :

(Against noise and heat and light I steady one palm
on your chest while the other folds a fist
inside you, your hand in my hair.)

After, I walk alone to the museum.
Fluorescent hallways of the body scraped clean.
In one gallery I find a small pair of hands
held in the hands to make the sound of applause.
Ivory clappers, the placard calls them. I think of
eleven-year-old Tom Andrews, hemophiliac,
who broke a world record by clapping
for fourteen hours. Decades later
during a bleed, he writes from the hospital
The pain is not personal. I am incidental to it.
It is like faith, the believer eclipsed
by something immense… Behind glass,
the quiet clappers have taken up prayer.
How long have they hung here—untouched
by warm palms—do they long for salt skin
and the vibration of a song—or do they settle
with gratitude into a life beyond utility.
A neutral place to rest. Just this morning
when I pressed my bare hips into the rough
second skin of your jeans, pleasure tipped
and became unbearable. Pain, my teacher,
reminds me how little we can live on.

For you, I conjure surrogate hands

They are not ivory, no, not iron,
wood, burnished gold,
granite, sandstone, quartz
or blown glass

They are, my love, made of water

They will always hold you

that begins with a great blue heron
tracing the Flat River east

rain loud enough to drown the sputter
of construction trucks in springtime

a sky that wants so badly to be new

the distance from river's hem to darkest blue

I do not want to talk about what can be held in the hands.

Now is not the time for seeds, river stones, dictionaries, pens.
I would prefer to begin with a little wind over moving water;

at the minimum, a whitetail's hoof print in the sand
or the fiddlehead's green hood still untrampled.

The banjo lies still in a black case the shape of its body.

Left hand and right hand convalesce
inside the black gloves designed for pain.

You play the tune this time, you hold the guitar.
I'll sing the word *power* so many times over

I become a train for whom the night rearranges itself.

Every night you sleep beside me
I undo the fitted sheet in a circadian tarantella
of open palm and closed fist

hands—

confused flowers in half-darkness
ask—

does relief lie in the furled bud or the blossom

Tonight, I would

ask the night doctor
to bring out the bone saw.

Clean, clean wrists.
I would replace

nerve and tendon
with silicone and steel.

The pain is a cautery.
It places me on one side

and everything I love
on the other.

Including you.

Story of the heron:

We are, each of us, a knife.

Body is born with a sheaf of questions in their furled fingers.
Who am I. What am I made of. What will become of me.
What should or shouldn't I. What is right. What is true.
What membranes divide me. How can I reach
the other side.

When Body is old enough to read, they haul the heavy dictionary
into their lap and look for their reflection in its pages.

bod′y, 1 bed′ı; 2 bŏd′y.

Body learns the definition by heart:

I. *vt.* [BOD′IED; BOD′Y-ING.]

1. To | **furnish** with a body; embody.

2. To put into outward | **shape**; represent.

3. To form into a body, as troops, etc. |

II. n. [BOD′IES², *pl.*]

1. The entire physical part of a man | or other animal.

2. The trunk, or main part, of an animal | or thing.

3. A person; an individual; as, some*body*.

4. The | principal part or mass of anything.

5. The box of a vehicle. |

6. *Mech.* One mass of matter, as distinct from all other. |

7. *Geom.* A solid.

8. A collection of persons, things, facts, | or the like, as one whole.

9. Opacity, density, or consis- | tency; substance.

10. That part of a garment that covers | the body: waist.

11. *Metaph.* Matter, as opposed to spirit. |

I am an outside, Body says quietly, shifting in their chair.
For the first time they recognize themself as a made thing,
like the log cabin their family lives in or the soft gray horse
they hug under blankets at night. Body wonders
if their self, too, is crafted of sturdy beams and tender
velvet—or some other material, still undiscovered.

Body learns it is best to be vessel. To contain
without leaking. Substance. Matter. Depth.
To stay whole and separate. Body is confused
about the consequences of breaking
but when the dictionary explains

Corpse and *remains*

they close the book
as if burned

Wind and water weather Body's wood house.
The horse, her velvet ears now smooth as seaglass,
sleeps in a chair beneath the high shelf
where the dictionary lies dormant.

Body uses world as scrying glass. To perceive is to dive
into divination, divinity. They collect everything—

construction work on the river bridge
salt grains biting the tongue
news about the massacres
curls of rusted wire on the sidewalk
electric currents of nerve pain
faggot shouted at them from a frat house yard
magnolia petals collaged over wet ground
a lover's small hand on the back of their neck

—learning from world
how to be.

Body collects methods
of disappearance. Make Body small.
Scrub Body clean of masculine or feminine
selves. Make them prettier
or more handsome. Repair tears
without fanfare. Make Body legible.

Others demand to know:

Is Body boy or girl or—
Are they hurt or whole—
Are they actually in pain or is the pain a nest
Body built of their own material—

Names rise around Body's ankles like cold water.

Body grows and grows up. They begin to sense
that something in them is different and something is also wrong.
An unspoken longing forms under Body's lungs
like a new liver. Pain knits hollow spaces between the bones.
It is difficult to separate the two. Body tires easily, cultivates
a garden of bruises and rice-paper scars in their skin's
perpetual spring, loses breath to arrhythmias.
They can barely bend to tie their shoes.
Body blames these symptoms on a desire
to smooth their best friend's hair behind her ear
and fall into her bed the color of sea foam:
a merciful drowning.

A revolving cast of physicians agrees, at first, with Body's own
diagnosis. The doctors offer self-help books (personality
disorders), birth control (mood swings), antidepressants
(dark cloud), pain medication (torn tissues), vitamins
(nausea, lethargy). Body becomes the absent star
of their own play; they wait behind the curtain
for any change in the doctors' monologues.

Body stops hiking among mountain laurels. They stop stepping
over river rocks. No more writing by hand. No more parties,
dance classes, late nights in the art studio. Instead,
they fall asleep early on a heating pad. They find
a steady job where they can sit down. They fall
in love with someone new.

One day, after all that, a doctor flings the curtain open
and drops *connective tissue disorder* at Body's feet.
A dead thing.

It lands in the water of names and floats to the top.

At night Body dreams splinters and worn-out
velveteen. They had tried so hard to be whole.

They believed the doctors, before.

Body took every name they were given.
Crazy, hormonal, psychosomatic, depressed.

Body's second life begins when they realize: I am more.

Body quits their job and begins, instead,
to remake a world they can live in. They replace
hard chairs with plush floor cushions, fill empty spaces
with red stones and golden feathers found on beloved trails.
They spend quiet evenings ripping seams and sewing hems.

The dictionary feels light in Body's practiced hands
when they pull it down from the high shelf.
Body rolls up their sleeves.
Picks up the white paint.

bod′y, 1 bed′ı; 2 bŏd′y. **I** [, BOD′Y]

form

a whole city,

as opposed to

hull

Syn.:

beauty

supported by bony framework

;

poetic
or
plain

;

; ;

an animal

— : intelligence

between the

viscera

and

—

an organized

grave

— —

— —

Body gives themself a new name.

They fill out all the appropriate documents.

When a friend slips up, Body breathes deep
and makes eye contact: *It's Animal Intelligence now.*

Before, when Body tried to describe the knowledge
in their bones and skin and dark quiet organs,
they would shake with fear as if on trial.
Today, they laugh.

The sound is a great ripple that emerges
from the core of Body's being
until the whole world
rings.

how old was I

when my mother gathered hellebores to float in bowls of water. I can still hear their sun-bleached voices, singing rounds known only to their paper skeletons. Where do the petals travel—where do they imagine they go—on those circuits, hours-slow, around the glistening rim. She used heavy scissors to clip the stems. The bowls were blue; they trapped rainbows. Her hands, quiet and sure, placed blossoms in new firmament. I could be neither fingers nor flowers, so I propped my chin on elbows to watch at the dining table. Which living stems did she cut. Which blooms immortalize. After a week, membranes thinned without the mother plant. The remains went to compost, the water to drain and the bowl to wash—

flowers, thoughts in the mind
endlessly remembered and forgotten

flowers, ~~thoughts in the mind~~
~~endlessly~~ remembered and forgotten:

the spring I noticed a pink magnolia in full flower was not its first bloom. Its laden branches lifted and sank under sky the color of lithographer's cyan, a cloud's choreography. Petals flew and fell so with my needle I sewed them up again. My own skin had just been stitched and un-stitched, thread embroidering the rise from hip to rib. It moves with me still, that red line, unfurling its cotton tangle until

every nerve and synapse
flares

becomes a
every nerve and synapse
flares

the moment a fragile object displays its limitations. The glass pitcher's round belly split when I filled it with hot tea. Inside becomes outside so quickly. Yesterday, a dish fell into the sink and split in three pieces— one dagger and two clasped hands. None were fit to hold my breakfast. Today I planted a philodendron in a teacup whose handle's long been gone, tendrils and leaves where a curve of clay should be, and

found some comfort in the transformation

my
[I] found ~~some~~ comfort in ~~the~~ transformation

from a vessel to a sieve. Everything wet and cold I'd been holding
could now trickle out of me, a punctured balloon. The plainclothes
doctor said that all of my familiar precautions were born of a
protective instinct: warm baths, slow walks, naps, pepper balm,
heat, no coffee or cigarettes. A reflex with no name or language,
then. I tried to hold together despite

continental drift
on a cellular level

imagine ~~continental drift~~
on a cellular level

hearing music on the mountainside and not knowing its origin. Behind a stone farmhouse in Cantabria overlooking the Atlantic, low-walled pastures spread towards sea cliffs. Fallen clouds condense into sheep and goats grazing, around each of their necks a hand-hammered copper bell with a wooden tongue. Scattered down the valley, the bells sing soft knocking instead of ringing, the way waves knock on ocean boulders all day

with only one answer

there is no
~~with only one~~ *answer*

when I knock on sleep's door at three in the morning. In meditation, the third strike of the singing bowl means *follow my sound to its very edges.* Only then, you tell me, should I open my eyes. The sound is not lost when it goes; it has traveled elsewhere. What happens inside the night that sets my mind's rim singing. Is my body trying to remember its aliveness. All week, when I do sleep, I dream the family dogs resurrected. They run out of darkness towards the house's mouth, then disappear inside. I pause at the threshold, listening— as shadows of familiar objects replace the fading doorway—for the bell's faint overtones

draining out of this world
and into another

draining out of this world
and into an[/]other

on my first walks in the southern woods, I became a hinge. At six or
seven, every tree stump was a universe, every bramble a pipeline of
wishes and wants. I was in equilibrium; my body was the same size as
my desire. I saw a drift of red clover on the creek's far bank and went
there. My belly was always full of sour leaves and sweet berries. I cannot
forget what it feels like to be expansive as gullies and fields. I cannot
reconcile, now, my smallness. This is how the land must feel:

disturbed by borders and boundaries
drawn on by an impassive hand

[I am] disturbed by borders and boundaries
drawn on [my] body by an impassive hand

but fascinated by edges. I have come to an edge. On one side, land; on the other, water. The place where they meet is decorated with algae and duck feathers. In some alternate world this could be the bowl from which I drink my tea or a whole galaxy of ocean, but here proportions dictate that I am a speck on its muddy rim. Signs tell where to walk and warn of deep or shallow water. Clouds circle the sky's lip until, in one last ripple, day drains from every surface—

have
how old was I [become]

[two]

the tangible universe

ma-te′ri-al, *n.* is

 facts, impressions, ideas,
 sketches, etc.,

 the amorphous substratum of reality

 l

 believe in

 bodily necessities

 developed into a *Spiritual*

 essence

 ‡

thorn, 1 t͡hĕrn; 2 thôrn. **I** pierce

 time

 ;
 I

 am
 makeshift

studded with o spine ,

 [THO I- , THO I-]

pain ; resent i t —

When I was nineteen I still believed my body could withstand anything. One gray afternoon at the Duke Gardens I wandered with two artist friends among bamboo groves and bloomless rose hedges looking for thorns. A barberry bush stooped low at the top of the sandy path gave what we came for: woody spikes, each with three spines radiating from one base like the spokes of an unfinished wheel. We snapped twenty-six from the stem, slipped them in a shoebox.

You rub my back during a pain flare and I remind you to avoid the spine. I say *the spine* because it is easier than saying *my body feels broken and your touch makes it real.*

I try to describe the days or weeks when I become unable to hold myself upright. I start to tell you how the biggest hurricane of my childhood lured dune after dune into the raging Atlantic; I mime the act of pulling the string from a strand of beads so quickly they scatter. These approximations do not hold.

Let me try again.

The specter of a tower looms on my mind's horizon. A power plant's elder smokestack, it presided over the walking path I once traced to work—two city blocks south, one east, one south, one east—and became a familiar pebble in my palm turned over and over. Snow melted in rivulets down the sidewalks and the pink magnolias were about to make good on their annual promise when a four-man crew arrived at the tower. Harnesses, hard hats, jackhammers, dumpster. They climbed to the top—brutal dentists gathered over the mouth of a lamprey—and began to pull every one of its teeth.

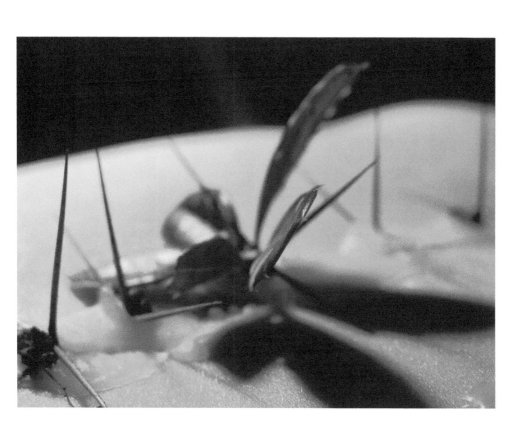

We brought our collected treasures back. In an empty attic warmed by space heaters, I took off my shirt. I was shy but I needed to know that words were more than sounds, that they could change and be changed by the body. She took the first thorn and, using the wax of a white candle, pressed it to a vertebra until it stayed. He held the camera, the light.

With a line of thorns down my spine I became.

The pain begins with a twinge near the thoracic spine. Exacerbated by: sitting, standing, lying down, carrying a bag on the back, carrying a bag on the shoulder, leaning over, stretching, reaching, walking, lifting, nothing at all. When the twinge becomes a gasping, I call the doctor. I get into the position my college dance teacher called constructive rest and wait for muscle relaxers to work.

I no longer live in that city, but when I close my eyes I see the tower's after-image: bright column on dark field. Demolition was finished by week's end. I had looked at the tower from across the street almost daily. I had never seen it. When its stature was so diminished that the men stopped wearing harnesses— reduced to a cross-section as the rubble pile grew—the smokestack spoke over jackhammer whine.

The doctor knocks, walks into the exam room with a sheaf of x-rays, all clean. They always are. Subluxations of the vertebrae and ribs are quieter than fractures and harder to trace. He asks me to stand, bend forward, touch my toes. It is rarely the bending that hurts. Pain arrives when I try to return to a way of being that has, in the stretch, become unfamiliar.

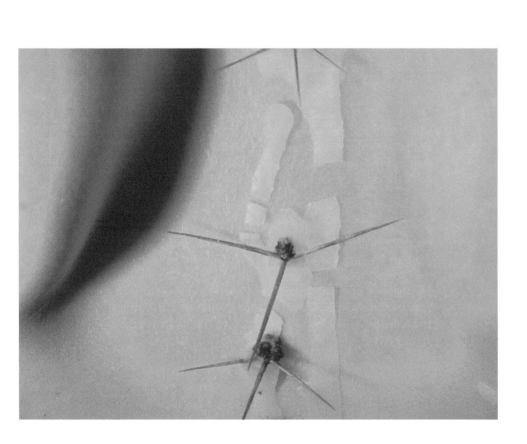

In a grainy video from that day I rise protective and slow; press arms against ribs to hide my nakedness; straighten; kneel; twist as if to see someone over my left shoulder, right shoulder; fold forward; cross my arms and arc all the way back. An invisible palm against my forehead leans me into a baptismal posture. Dried wax crackles into a halo on the velvet.

I first kissed you beside a dying campfire in the place where the Mississippi and Wisconsin rivers converge. The plainclothes doctor diagnosed me three months later. Diagnosis denuded the pain. Before, I slept on the ground, hiked sandstone bluffs, sat on a beer cooler and played banjo to your guitar. Before, I was eroding but erosion didn't haunt me.

When pain comes at night I visualize the joints, in turn, as beach sand compacted by a hiker's boot; rusted engine parts of my father's old F150; beech tree limbs broken and groundscattered by an overnight storm; a menagerie of house wrens, great blue herons, cedar waxwings, Eastern bluebirds, redwing blackbirds, barred owls, turkey vultures, and redtailed hawks, calling and crying and molting in the branches of my body.

The sky has a hole in it. Brick and mortar gone as if raptured, with nothing but a circle of concrete visible from above to prove the tower's absence.

I am cheese cloth. Sieve. A honeycomb of hurt. I imagine my body the way I imagined the constellations as a child looking up—a bolt of black velvet pricked at the site of every star.

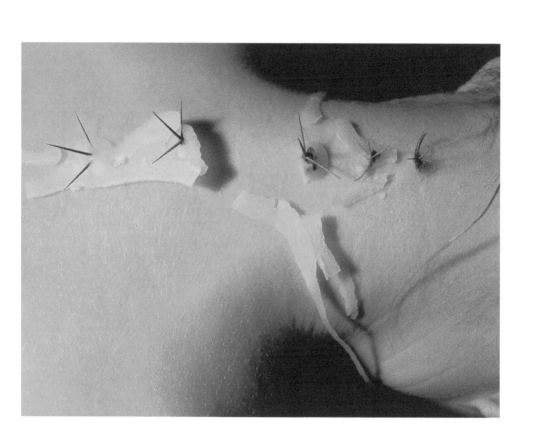

Cold room, hot utility lamp. The tough barberry needs no protection from its own weapons, but I was both soft and sharp. She placed the final thorn and stepped away.

I have forgotten so much but I remember this: rising from the floor with a back become thornbush, new body bristling.

Now it is November, and the radiators in my apartment are bleached bones, vertebrae perfectly aligned. Outside the window everything is white. In the new city my daily walk passes a dark red chimney in a back alley split from any house. It stands healthy and humble without crumbling. I turn my head away when it enters my vision.

I am so sorry, so sorry, so sorry. If anything spoken three times becomes incantation, I will apologize in threes, Body, until my tongue is raw and my hands sore from prayer.

I am sorry for not knowing how to relieve the suffering mapped onto our bones.

I am sorry for the stiffness, the soreness, the absence of connection.

I am sorry for remembering the sharp nodes of pain and forgetting, sometimes, the simple pressure of a lover's hand on my back.

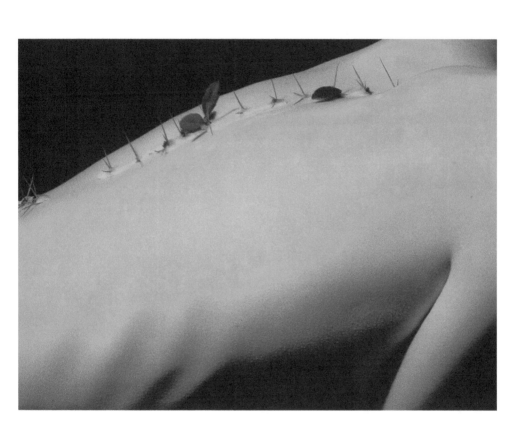

In my top dresser drawer I keep two long white tapers. During a spring of doctor visits, when I lost my body inside paper gowns, you drove us back to my apartment after an appointment and I opened the drawer. *I need to know that I still have a body.* I pressed my face into the pillow; you kissed my shoulder and lit the wick. Wax sutured the wound between my self and my self.

Sometimes you kiss my naked vertebrae, pressing your mouth to every thorn. Bless these sensations more tenacious than pain.

I have kept photos of my thorny spine in the back of a flat file for a decade, relics of the self cast in amber. In them it is possible to alter my course. White wax trickles between trapezius and latissimus dorsi, fixing woody spikes to human skin. Green leaves bud and open. The images embroider a universe where human body and plant body merge at the mouth of the void.

A nearly unbearable pleasure: in a fresh bath, body lowered and leaned back, the slow seduction of a bubble sliding up my spine to surface and disappear. Then I am alone in the quiet water.

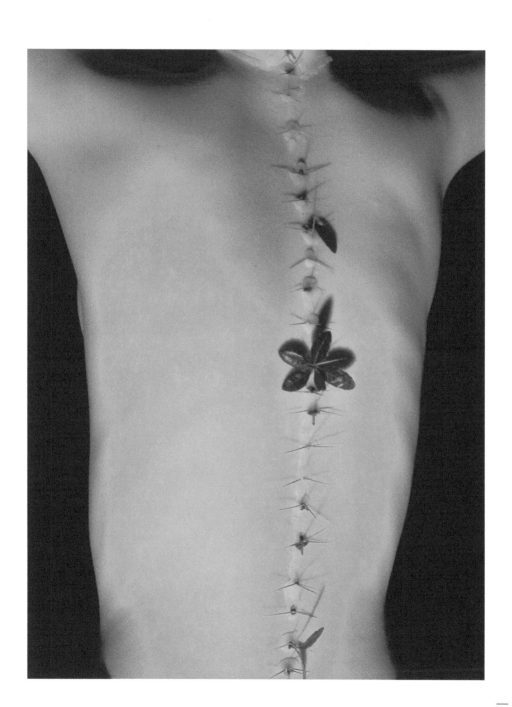

nee–dl(e ,

 wing

 bone

 used

 as a compass

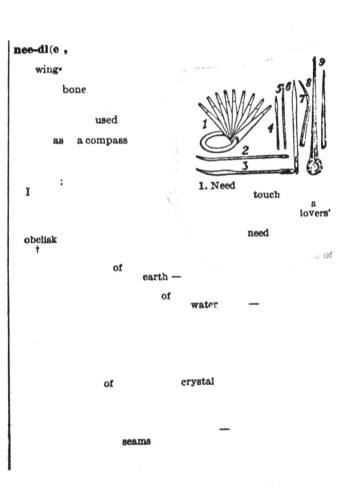

 :

I

1. Need touch

 a

 lovers'

obelisk

 †

 need

 of

 earth —

 of

 water —

 of crystal

 —

 seams

When I was twenty-two, in early spring, a lover-collaborator and I embroidered fifty stitches into each other's backs with a sewing needle and red cotton thread.

It started in January, when we began to write to each other across a temporary distance.

Our words cut digital trails over snowed-in mountains.

I want to protect the intimacy of our exchanges, but I can tell you this: though we wrote about language, philosophy, god, it was the act of writing itself that began to vibrate between us.

That red line.

The way it holds me, still.

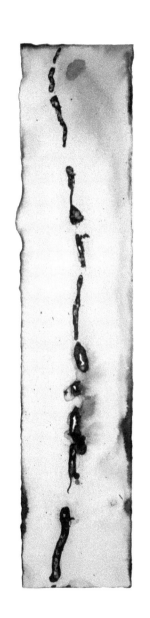

Our letters revealed a shared desire to reach the skin-side of language.

Typing on a screen—translating the tangible universe into dark marks on a blank field—was too far removed from the neurons and hands and nerve endings that engineered the writing.

We wanted our bodies to pick up where language left off.

I don't remember which of us first spoke the words.

(what if we embroidered text into skin—)

Sewing was intimate and visceral. It would take time. It resisted a tattoo's permanence.

As the Vermont air sparkled with ice crystals, I closed myself in the bathroom and practiced making a circle of chain stitches above my left hip.

It was a winter pain.

Sharp, cold, high-pitched—darkness concealing an ever-growing light.

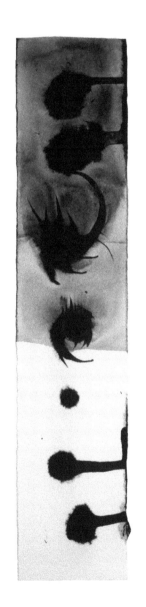

February found my lover and I together again in my narrow bed.

We propped ourselves on pillows while I gave him a sewing lesson.

It became clear that embroidering whole words would be both too
difficult and too literal, so instead we each designated a field
the other could sew—his shoulder blade, my lower back—
and agreed for a line to be stitched there, following the body's contours.

Time pulled taut between the present and the date we had chosen
just before Easter.

We bought thimbles and a fresh pack of needles; cleared furniture
from one side of his small white room and created a sewing space
on the floor with all of our supplies; waited for the day to arrive.

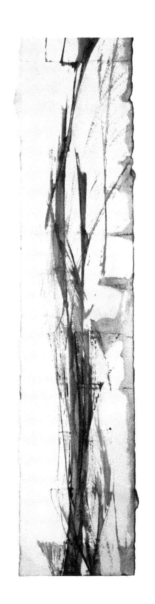

There is something I need you to understand.

Before my back was embroidered, I was a mind-tower
controlling a body from above.

Ache—of pain or longing—was a cluster of red lights
flashing impersonal, inscrutable signals on the horizon.

Fifty stitches burned the tower down in a single afternoon.

I became all body.

We left the embroideries in overnight and I remember panicking
at a friend's house that evening about not being able to bend over
to tie my shoes.

The thread pulled tight and said *no*.

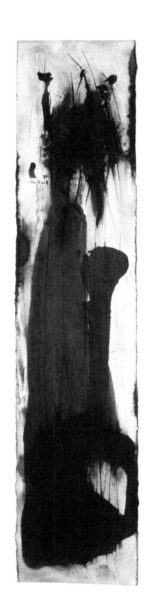

The following day, my collaborator and I spread a blanket
on the grass and invited a few friends to watch us remove the stitches
with tweezers.

We placed the threads in a muslin pouch, which we burned
and blew into the wind.

I took off running into the high meadow as soon as we finished.

I wanted to be inside sky : correction : I already was :
all my gaps closed : I had been made to open entirely :
I was not either-or but an everything wrapped in skin :
left in a sensory wilderness without map or compass :
everything brighter denser louder closer than before :
the spring air was violently loving :
the sky had never been so blue :

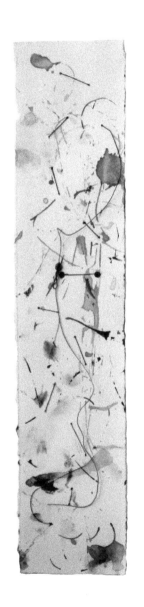

My lover's skin healed in a matter of weeks.

For a year afterwards my back remained speckled
with a galactic swirl of white scars.

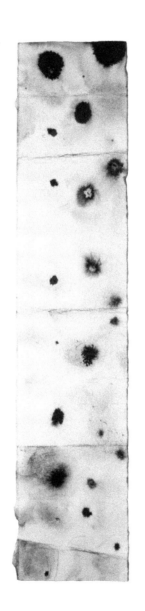

I can sense you waiting for me to describe that little white room
where his steady hands made a quilt of me and my needle illuminated
his shoulder's hidden language

but there are parts of myself I cannot give you
and this is one. Is it enough to say that I ended
and began with thread in my back

is it enough to tell you
that the needle opened a door

I stepped through—

I have lived ever since
on the other side

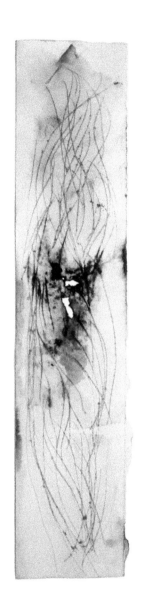

Body is not a bloom
but a blooming

performance between naked
twig and tender leaf

they remember
courtyard

branches twisted black
all winter

handfuls of soft cloth spilling
into ready May air

Body ties garlands of fallen petals
back onto the tree

to recover
what they've lost

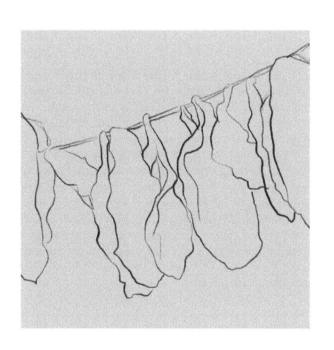

To inhabit a body with secrets welded inside every cell is to live in a place without learning its landscape. Four seasons of blooming went by before I noticed the little gnarled tree in a corner of the courtyard, wedged between brick wall and concrete ledge by the path I took daily to my studio. The dotted line newly etched into my back was an oculus, drawing me towards the pink magnolia until I saw nothing else. I grew up climbing elephantine saucer magnolias in my southern birthplace—their white flowers bloomed all summer and grew larger than a human heart—but these northern blossoms fit in my palm and bloomed feverish and brief. Furred shells kept the buds safe all winter until it was time to open. The gesture was viral. Big strips of flesh coming undone. So tender, so easily bruised. I saw the tree seeing itself in mirrored glass and metal. I tumbled. Between winter and winter, the hard husk splits.

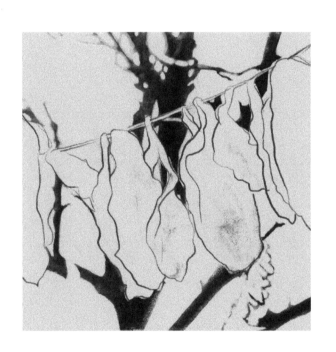

Wind started to scatter the blossoms the day after they opened. I couldn't breathe. All that beauty wasted on my memory, a vessel full of holes. I wanted to protect. If I couldn't prevent the petals falling I would keep the wet earth from erasing them. At first, I thought I would gather all the deconstructed flowers I could and take them home to dry. But I heard the tree's clear instructions:

pick up the thread / then the needle / make no mistake / your sutures are not a fix / just as this falling is neither fault nor falter

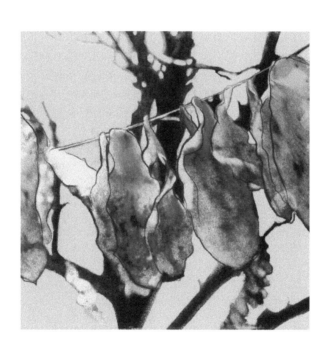

It was not the flowers' death that hurt me, but the way the tree would lose them when they dissolved into the ground. Sewing became both question and answer. Another answer: a few years ago, a friend died. She loved colors and built whole worlds of them in her paintings. I tried to write about her but I had no words, only an accumulation of pigments just under the skin. When spring came I took a year's worth of dried bouquets, pressed wildflowers, petals tucked in drawers, and ground them into a bright ash of yellows and pinks and blues and oranges and deep deep reds, the colors of her paintings and the walls in her house. I carried that kaleidoscopic dust up to the highest point in the Governor Nelson prairie, past the tree line with a sketched western view of Lake Mendota, where a single redtail wheeled above me as I stood on a wooden bench to let her go.

And where was she then / everywhere.

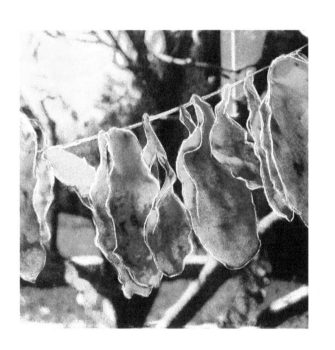

feath 'er, }
feth 'er⁶, } **I**

become

 you

to recover

ou r
collective

after :

future

—

A very thin edge

with
veins

of

light —

beside myself (the sea) gulls and cormorants form little cities on boulders clustered offshore unafraid of waves they live here all year / remember the summer you and I drove to the Green Mountains across new prairie and young cornfields looking up *what's that one* we said to each other *hawk maybe vulture eagle could be* / at the tourist hotel in Niagara Falls I was disturbed by our collective ignorance of the sky and those who live there I left you in our dark mildewed room to find a bookstore flipped through every North American bird guide settled on a little yellowed paperback *Knowing the Birds* whose author was unperturbed by inexperience cheerfully compared avian silhouettes in captions instructing *bat, not a bird* / you once said *I tried so hard not to love you* we both failed I have wanted and wanted you I follow your living ghost retrieve your dropped feathers you appear as a pane of stained glass in dreams I collect primaries and down fluff to reconstruct our lost life I never find them all claimed by sea or danger some become bones too gruesome to pocket I must recreate shaft barb vane after-feather in my waking hours how else can I reach across our cycles of silence / if you read this while you are away please know I loved

in truth I was angry you had found a shot to return you to yourself I pushed the plunger into your thigh on Sundays it is not kind I did want you to be well I did want us to be whole my psyche's interstices oozed bitterness jealousy resentment / weeks before your first injection you sat with me in the exam room as an ortho surgeon filled her palm-length needle with cortisone she couldn't sew my trembling rotator cuff back together connective tissue like cheesecloth overcooked pasta wet leaves in storm drains I had imagined making similes and metaphors of the experience but later all I could manage was *it was as if someone held a long needle against my shoulder joint and pressed it in* / my body tore itself to bits in my sleep you grew stronger brighter warmer beside me I was afraid your masculinity and my disease would conspire to erase me it is not flattering I did try to see my splintering as a kind of beauty I am still trying / the first day of your becoming we drove to the inland ocean and walked apart on its windy shore I tracked your blue hat down the beach as if you were a stranger / face down at my feet a gilded flicker's longest wing feather shone gold on overcast stones waiting for me as I waited for you until it was time

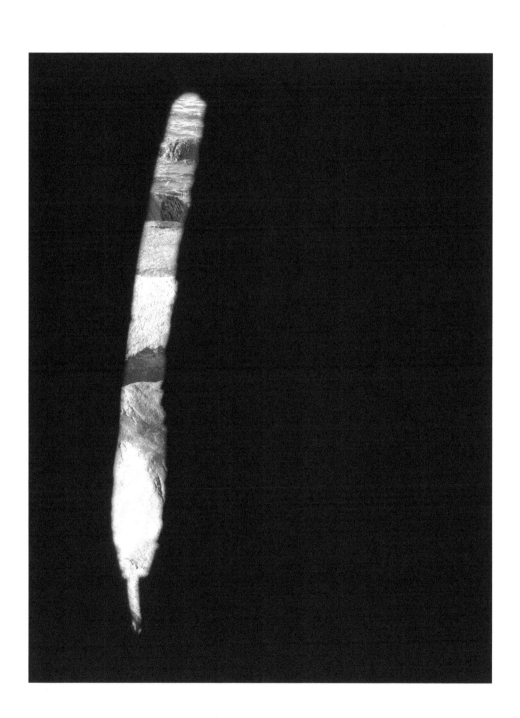

I recognize you from a city block away I have memorized your midnight silhouette stitched onto orange streetlamp downpour dark curls pressed under your gray knit cap you move like someone treading water / in this memory it is always new moon dark the street deserted just you and the lake surging after late-autumn rain / I walk a separate circuit around the city knowing a thread will pull tight between us when it does I pretend I cannot translate your knife-set jaw grief clamping your hips / I still search for you on night walks in every city I may always be sketching you on approaching horizons / I trace prairie trails when I want to be free of you / even there the gentle pair of Sandhill cranes hunts insects in tall grass their bodies always oriented towards each other / a stone-gray feather lodges in my trachea the vane trembles higher in the meadow a single curved plume stands straight in mud perfectly clean a flag of surrender survival supplication / your warm breath on my neck our bodies curled together again through the window a streetlamp burnishes your softened mouth / you reach two fingers into my throat / pull out the ragged quill

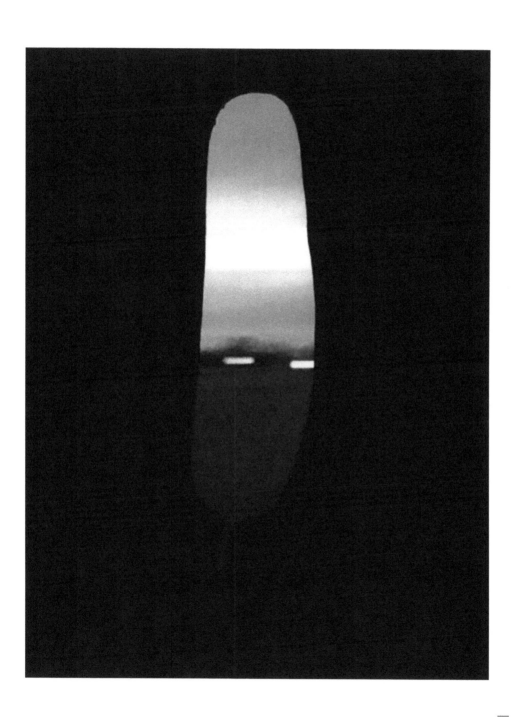

in feathers blue is not a pigment but an architecture of light barbs bend rays until they beckon bright from one angle dull from another / I found myself kicking yellow leaves on the trail with a new lover when the slightest bluebird trace of you glinted cold fire amidst all those warm colors / time to change course / what did I miss most in our months apart your teeth on my earlobe your warm breath on my spine as we slept the quick eruption of your laugh that little worry line between eyebrows your hand in mine those simple things I have stopped wanting from anyone / remember the picnic blanket we spread out in early spring by the lake it was still too cold but sun soldered sky to new willow leaves we couldn't wait to stalk the redwing blackbird in his green-gold bower / every new season we learn to position our bodies differently / a careful self-holding / I am no longer cartographer of your chest thighs forearms wrists now I chart the territory between us currents seasonal winds continental drift shoreline shape-shifting after tropical storms / swallow the sickle moon's downcast eye

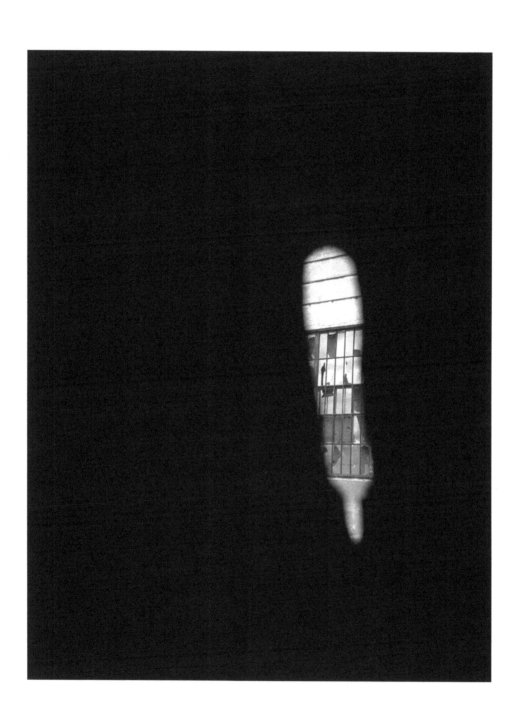

far away from home I fabricated a new body of palmetto frond armadillo scale eagle talon jellyfish tentacle manatee skin my back a jagged constellation of scars *will you still desire me* / I built a door in the sand hid my tenderness behind it locked you out I made I broke I rendered I planned plotted I I I I I never told you how grateful I was for long hours of winter silence sturdy brown wing feather long as my thigh steady in the windstream coming off the Atlantic vivid in my hand painful to hold impossible to release / I lost our language your sternum under my hand untranslatable across geographic distance I kept a record of our descent but revisited the marks are inscrutable / why is it I can never remember trigger or resolution only a pale afterimage of your silhouette in the driver's seat sleeves rolled up determined to get there *where are we going* before dark

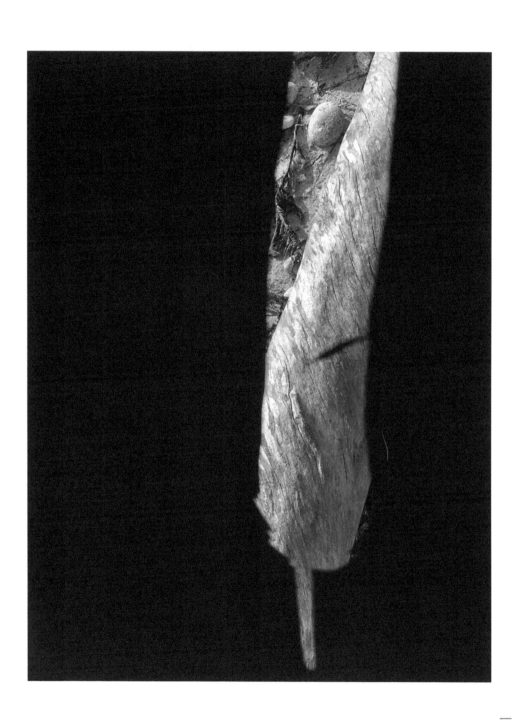

let me put it simply / seven years I have loved lost longed for you / gray vane tipped with saffron lunula / we are planetary out for a long loop in the cold galaxy hit a tight curve return every few months to meet in the solar glow / little waxwing feather in my path not once but twice / first on a sidewalk near the lake's edge in our new city I folded it into a book brought home to you apology for my past and future transgressions / we moved in together but never quite settled / I only wanted your hand to light on my sore right hip under blankets you wanted to go to bed I stopped sleeping sat up in the spare room to watch traffic light force the nearest tree's leaves into an accelerated autumn *green yellow red green yellow red* arboreal Sisyphus we are always back at our beginning / the second feather finds me alone in southern woods I love lose long for you in silence now your absence small in my palm scavenged from leaves on the dry creek bed / I recognize the shadow curve of depression glinting arc of love letters hidden in my dresser drawer / little feather weightless in my breast pocket I bring you home to keep safe and nameless

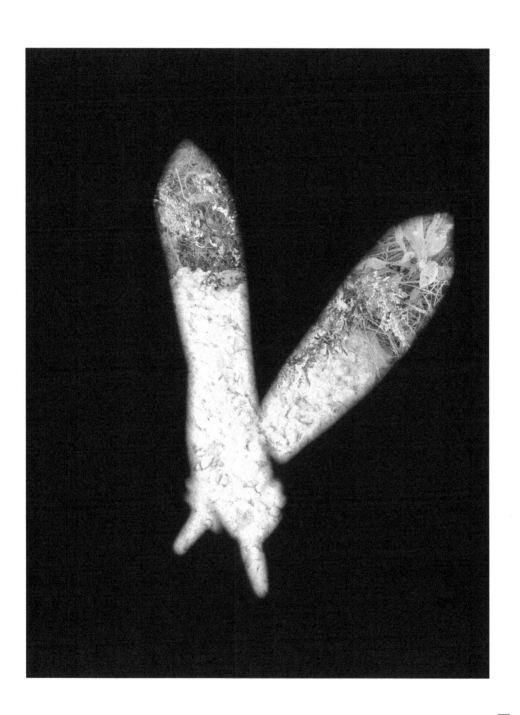

late in our first year there was an arc / you couldn't look at me we ran into each other everywhere remember the night I bent back on your bed something in me howled the night you held me through a panic attack the morning I brought you tulips to apologize for things we hadn't yet done the first morning I woke up without you the second first the third first / there are two sides to this one blue one white a curled breast feather the heron dropped in tall river reeds / the sky has no inside just territories of condensation / the last thing I'll say my love / I remember everything

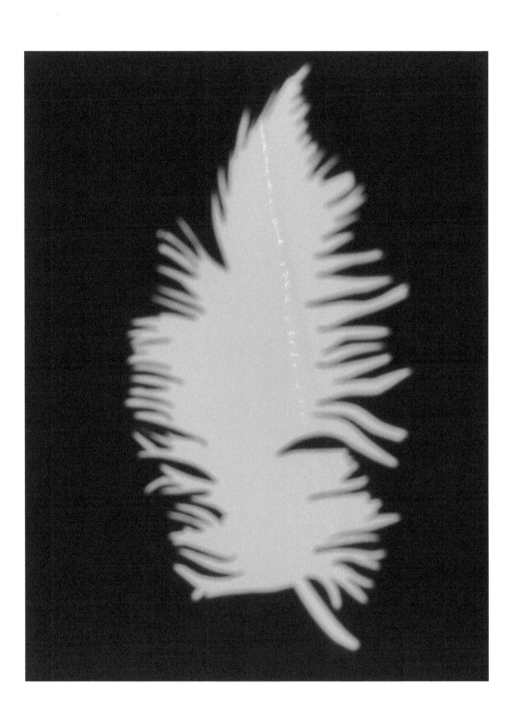

rust, 1 rʋst; 2 rŭst

I

consist

((
in an extended sense
)

of

corrosive

red —

When you have been unwell for a long time, you begin to notice objects that reflect your condition.

(Today I will write *you* when I mean *I*
I would like to step away from this narrative
like the party host who lights a cigarette in the dark
backyard and imagines, for a moment, being elsewhere)

You remember your father warning you not to leave tools outside after using them. He showed you how to dry the hammer's metal head with a soft cloth. After repairing the tractor he put his wrenches in the oven on a low setting to evaporate moisture trapped in seams. His reminders always came after you did the unspeakable: you forgot to safeguard the metal things in your possession. They began to rust.

(Imagine yourself as my
temporary surrogate: I settle my body
over your shoulders, careful not to suffocate you,
invite you to please take a turn steering this rusted hull)

The various moving parts of your body remind you of the Philips-head screwdriver you once left in tall grass and the steel kitchen knife you forget to dry after washing. Each day seeds of rust take root inside the joints. The redness has a smell.

(With every move, the body grinds.)

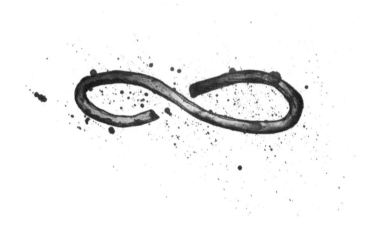

Fig. 1. Rust is something you can cultivate. You want to prove this to yourself. It is not only a sentence.

(In bed, when my hip slips
its socket with you on top of me,
you ask me to describe the pain; all I can offer
are instructions for building your own rust collection)

1) Be the magpie's opposite. She seeks and finds shine; you watch for dark shapes in the gutter. 2) Walk often and clumsily. Sometimes you will trip and see the ground from a new angle. This is good. You may even stumble over one of those dark shapes you so desire. 3) Frequent city sidewalks, railroad tracks, the cracked asphalt edges of parking lots. 4) Do not think about your actions. Do not question them or hunt their source. Above all, do not write about them. 5) Every evening, empty rusted bits from your pockets into glass jars. Wrap a few objects—washers, screws, et cetera— with string and suspend them from skeletal branches of driftwood. Set heavier pieces on window ledges and the tops of bookshelves. If you pick one up from its station in a few months' time, you'll find a halo of fine powder the color of dried blood. 6) Reserve a few special parts of the collection to carry on your person as a reminder: you are the museum and the museum is you. When it's time to explain the heavy ache in your joints and the fragile dust of your connective tissue, slip a hand, hot and sore, into your pocket and retrieve a lump of iron twisted beyond recognition, its weight your newfound language.

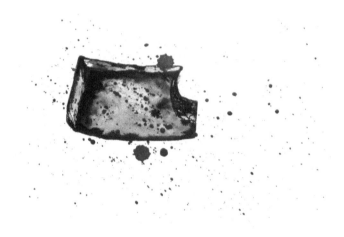

Fig. 2. If others ask you to explain your rust collection, say *I hope you never understand.*

Each new scrap of iron in the gutter tempts you to name your attraction. *I am like you, we are family, your degeneration is kin to mine.*

> (How long
> will you be able
> to bear it, I wonder)

Resist this.

> (I do not want
> you to hurt as I do (do I)
> but this may be the only way)

The act of picking up a piece of rusted metal and carrying it home must remain untouched by language.

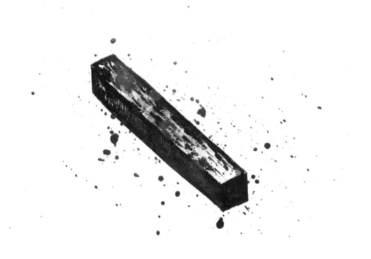

Fig. 3. Despite your best efforts, words spill out of your skin and clink against each other on the pavement.

(At the beginning of our separation
I move out in the dead of winter; though
you disappear until I have finished packing
I ask you to carry this last heavy thing for me)

Friends find you nested in the living room among boxes labeled
*STICKS FEATHERS & ROCKS. DICTIONARY COLLECTION.
RUST.* With a torn rotator cuff you can't lift the things you love so
you wrap each piece in newsprint and ask your friends to load these
boxes into the moving truck as carefully as those marked *DISHES*
and *ELECTRONICS.* You stand in the doorway. Remind yourself to
get another tetanus shot.

Your first dream in the new home: you stand over the smallest,
heaviest box, heart beating fast. A thin wail escapes from folded-
down flaps. The clean cardboard you expected is diseased with an
infestation of rust. Midas's nightmare. Your fear, manifested: the
body corroded beyond recognition while you sleep.

Upon waking, you seal the little box with extra packing tape and
hide it away. In this clean place you can't bear these specters of your
dislocated jaw, unhinged hip, shoulder's loose socket.

They will speak even from the closet's dark quarters.

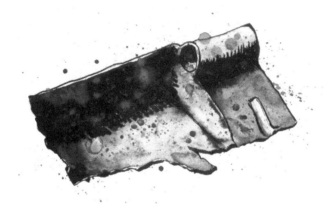

Fig. 4. Even if you threw each piece back into the gutter, it would be too late. Rust has already collected you.

[three]

But if I don't write it I won't understand[1]

> What is left to understand.
> Here is the body, breaking.

I must re-create it in the form of a story

> What is left to tell.
> Here are the cells, slit and slivered,
> shadows of impossible futures.

That's the only way I can somehow get close to it

> What is left to approach.
> Here is the here, the inside of always.

I have to dance around in front of it, I have to move,
not freeze like a mouse who sees a snake

> What dances remain. Here is the left hip,
> here is the right, here is the folding chair
> by the dance floor for the moment of slippage.

1 The left-hand text in grayscale here is quoted from David Grossman's
book, *Falling Out of Time*. For more detail, see Process Notes on p.130.

I have no other way
You have to get that: *I have no other way—*

 The other way—well, you know,
 I shouldn't have to tell you.
 No more scattering words
 from your hands onto the ground,
 birdseed—for whom.

I want to knead it—yes, it, the thing that happened,
the thing that struck like lightning and burned everything I had—

 What is left to knead.
 Even a book is heavy as blood in the hands.

Here at my desk, with the rain coming down
just past the roof's overhang, window glass dry for now—
here, with a cheap ballpoint swiped from the bank
and clean ivory paper in a neatly-bound book—
here, with feet propped on the windowsill
under the desk made by a stranger's ex-husband
and purchased from her for $20 in a hotel parking lot—
here, in a dim room full of houseplants and books and,
for the first time in weeks, quiet—here I am trying to begin
to try to write the name of what has no name, no signifier,
what cannot even be uttered, what I should kick
back into the rainswept gutter for the eventual sea to take in
as it does with all our mortal refuse, where it will settle
under the continental shelf, uncontemplated by anyone—

Let the sea. Let the water. Let the salt seawater take this stone
and sink it.

I am always at this desk. Even when I spend weeks
dancing around it like a snake who sees a mouse.
Or a mouse who sees a snake.

Which one of us
is hungry for the other.

Just before sleep I perform an imagined repair,
suturing the painful joint spaces with a thread
of goldenrod light against a blueblack field,
as if I were a child again and my parents still awake
on the other side of the door.

 If I write it: what is left of light.

There is a struggle—do you know it—at the seams of the day.
A moment when I wonder, still, which way
the sun will go. As if it were possible to watch twilight
brighten and blue. As if witnessing could change the sun's course.

 I mean to say: As if writing
 could change the fact of the body.

[arranging nets for mending: four centos]

did you get my last letter I no longer have any pretense to keep up
my body is a series of knots meeting at the point of most damage
I walk through my urge to record its starting point

across the wall illness cuts a violent circle put out the nets

in this new world alternating submergence and exposure
I put out the palm of the hand towards a hole I can't touch
or name it is essential that the needle moves

two loose ends remain knots untied to extend their useful life

to use my body I must go back between foliage and breaking
waves illness made a wilderness of me do you understand
I teem with wolves press myself against rocky shores

the anchor gave way soughing and sighing *choose a door*

if it is convenient to sit down I feel like a criminal
like a skinned rabbit helplessly bound to my horrible dream
I long for that moment when the door will open

truth is I don't hear a sound put out the light

Dear Body.

This morning the sun through my bedroom window
is clear and strong.

There are so many things to say about the sky
but I can't write them.

Inside, it is raining.

A fine-spun mist, not the electric hurry of a downpour
before lightning and thunder. A rain to rely on.

Soaking into the ground. Nourishing what grows here.

You know as I do: water takes as it gives.

The surface begins to rust. A second skin grows
that can never be shed.

Do you remember the rains of our childhood
that washed away red clay hillsides
carried all that soil into Dry Creek down below.

Roots of the beech trees and pine trees breathed air
for the first time.

There was no way to cover the roots back up
as when you fall asleep early on the couch
and our lover drapes soft fabrics over you, Body,
you sleeping beautiful hillside—

only nakedness

your flesh falling away

bones clattering after

the great sound of the rain filling your ears
and vibrating your nerves
sweet frayed threads
after all this.

All week our pelvis has shifted in and out of itself,
attempting to transfer to a new dimension.
It keeps snapping back into a glitch. Time twitch.
In some part of the universe, Body, we could be well.

I cannot leave the metaphors even for a moment.

The straightforward language is too naked. I can't bear it.

I write and rewrite these words because their diagnosis
is irreversible. Some part of me hopes
we will wake up one morning and be healed.
But you no longer believe we will stop hurting.
A consequence of clarity. Or: there are
only different frequencies of hurt.

For you, Body, I will not write about healing in the sense of recovery.

This is not about pain, though I keep writing the word.

This is about the condition of being in love.

Nerves catch fire—heart races—we stay awake all night
with an inescapable awareness of every living and dead cell—
every movement is of utmost importance—every touch
crackles with power—our aches are both acute
and ambiguous—it is difficult to move but impossible to stay still—

deep inside us, something is banging on the walls
too full of feeling to be suppressed, too alive.

You and I, we are dance partners orbiting
our conflicting desires: I try to make plans, to
exercise caution, to build a world in which nothing
else can hurt you. But Body, I know you are willing to
risk the consequences of pleasure—I feel you ache to reclaim
the territory pain has staked in you—you live for the red rising moon
that can only be seen from the steepest cliff above the Mississippi,
for the lover who bites your nipples raw, even for the knife
wedged in your left shoulder joint as a reminder:
despite the illness, you are still alive
enough to hurt.

I haven't slept in a bed with a lover in four seasons.

I always come home to you, Body.
You hurting thing. Pain has become a way
of keeping company. I made room.

Degenerative, doctors call you. And yet.

For me, you are generator.

Sensation architect.

Weathervane.

Hillside.

Shore.

[meet me in the garden] at the start of the season

 when the magnolia is just

beginning to bloom. Raspberry brambles behind the house grow

 vivid with leaves—

the cedar, green all along, doesn't begrudge the forsythia

 its alchemy—

there is no blight, no waterlogged soil, no sun-starvation yet—

 there is still time.

Let me be clear: I do not want to love you in a world

 without winter.

I would not know how. But for now I will undo seedlings'

 knotted roots

so others may flourish. Alive among monuments, we

 touch

without checking the clock. Here, even alone, I can see your face in

 my hands,

your blue dimensions. Above the vines and wildflower beds our

 broken bodies

tower over us, carved in stone, veined with mosses and lichens,

 no longer

ours. They are quiet. Relieved of the duty of

 holding.

Promises to the book before final revisions. Pen, ink, and gouache on paper.
Created at The Lighthouse Works, Fishers Island, NY 2017.

Dictionary usage: All dictionary definitions, including erasure poems, are sourced from the *Funk & Wagnalls Practical Standard Dictionary* (1943) unless otherwise specified. I found this dictionary at a Vermont junk shop in 2008 and have been carrying it around like a bible ever since, tucking photographs and letters in its pages. This particular dictionary's text is lyrical and even whimsical in places, and the accompanying illustrations are rich sources of interest. In the process of making this manuscript, I photographed and then digitally altered select definitions in order to retain the original appearance of all typography and diagrams.

Etymologies are sourced from *The Online Etymology Dictionary* (etymonline.com), unless otherwise specified.

Images: All images and artwork are by D. Allen unless otherwise specified.

section one [p. 11-38]

If I describe the pain as a barrier to love – The poet Tom Andrews broke a Guinness World Record at age eleven for clapping his hands for over fourteen continuous hours. The italicized quote on p. 13 (in bold below) comes from his long lyric "Codeine Diary," from his collection *The Hemophiliac's Motorcycle*, made generously available online as a free PDF by the publisher (University of Iowa Press, 1994):

> "There are times, in the last minutes before I am allowed, or allow
> myself, more codeine, when the pain inside the joints simplifies me
> utterly. I feel myself descending some kind of evolutionary ladder
> until I become as crude and guileless as an amoeba. **The pain is not
> personal. I am incidental to it. It is like faith, the believer eclipsed by
> something immense** ..." [64]

My reference to "ivory clappers" refers to a display in the Minneapolis Institute of Art, Minneapolis. The placard reads: *Pair of Clappers, about 1550 – 1292 BC / Ancient Egyptian / hippopotamus ivory*. A description and photograph of the clappers is available at collections.artsmia.org.

Many thanks to Raymond Luczak for publishing an earlier version of this poem in *QDA: A Queer Disability Anthology*, alongside so many phenomal writers.

The story begins – *I'll sing the word power so many times over / I become a train for whom the night rearranges itself* references Nina Simone's incomparable "Sinnerman," from her 1965 album Pastel Blues, in which Simone sings the word "power" 40 times in the course of the ten-minute recording.

Jillian Weise's poem "The Body in Pain" (*Painted Bride Quarterly*, http://pbq.drexel.edu) from her excellent collection *The Amputee's Guide to Sex* (Soft Skull Press) was hugely meaningful for me as a disabled reader before I wrote any of the pieces in this collection. Here, my line "I do not want to talk about what can be held in the hands" echoes her line "I don't want to talk about any of this."

Thank you to the editors of *Poetry City, USA*, for giving an earlier version of this poem a home.

<u>Autobodiography</u> – Huge thanks to poet-genius-collaborator-force of nature Roy G. Guzmán for not only giving me valuable feedback on multiple drafts of this lyric essay, but also for giving it a home in Connotation Press as Featured Guest Editor.

<u>Singing Bowl</u> – Thank you to Jill Khoury and Jen Stein Hauptmann for giving a previous version of this piece a home in the always excellent *Rogue Agent Journal*.

 [p. 41-106]

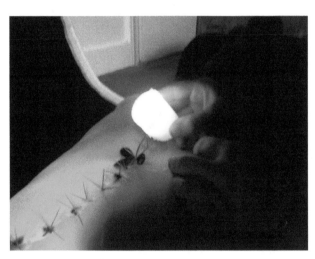

<u>thorn</u> – The photographs for this piece were created in collaboration with Hannah Sabri Barco, who applied the wax and placed the thorns on my spine with great care, & Andrew Barco, who created a warm, supportive, and visually striking environment (Durham, NC 2006). Both collaborators took photographs; the physical body and the concept to manifest the etymological connection between *thorn* and *spine* were mine. Many thanks to you both for your friendship, collaboration, work, and hearts, which have influenced my own for many years.

Additional gratitude goes to the Andrews Forest Artist Residency in Blue River, OR, where I wrote the first draft of this piece in March 2014, and especially to research geologist and ecosystem scientist Fred Swanson, who generously oriented me to the forest and offered his valuable insights and supportive presence during my residency.

Thank you to the following editors and publications for publishing versions of this piece: Ching-In Chin, *cream city review*; Raymond Luczak/Squares & Rebels Press, QDA: *A Queer Disability Anthology*; Nicole Oquendo/Sundress Publications, *Manticore: Hybrid Writing for Hybrid Identities*.

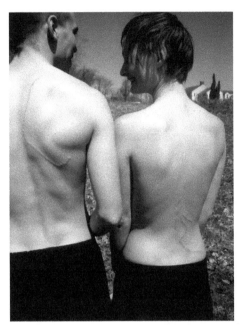

needle – After drafting the original version of this text, I created the drawings using India ink and a sewing needle as the only mark-making tool (Minneapolis, MN 2015).

Huge love and gratitude to Niko Tsocanos for all of it, and for encouraging me to share this version of our collective experience. Thanks also to the friends who helped us document and celebrate the process.

Additional thanks to the visionary Ray Gonzalez and my classmates in Ray's lyric essay course for which I first drafted this piece, and to Kayleb Rae Candrilli and the other folx at *Black Warrior Review* for believing in a previous version of this piece and giving it a loving home.

petal – In memory of Viola Moriarty.

These digital drawings were rendered from an original lacquer transfer monoprint (2009), which I created from my original photograph of my outdoor installation *Magnolia performance: To recover what's been lost* (North Benningotn, VT 2009). In this work, I used sewing thread to create garlands out of fallen pink magnolia petals, which I then tied to the branches from which they fell. My dear friend Sarah Pike reported that the dried petals remained on the tree eight years after the installation. Thanks to Olivia Spitzer for photographing my installation before and after its completion.

feather – While drafting this piece, I was reading *Alchemy for Cells & Other Beasts* by Maya Jewell Zeller and Carrie DeBacker and *Irradiated Cities* by Mariko Nagai, both of which influenced my thinking about the poetic form and the relationship between images and text. These photographs are the result of numerous stages of image-making: while at The Lighthouse Works residency (Fishers Island, NY 2017) I created life-sized gouache paintings on paper, from memory, of feathers I had found in various locations over six years; cut the paintings out using an X-ac-

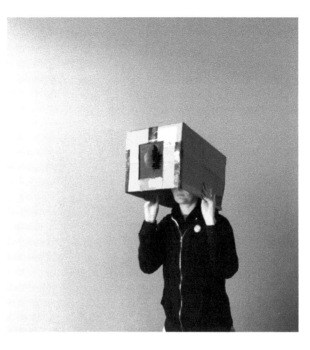

to blade, leaving a black stencil; transformed an empty cardboard box into a wearable viewfinder to hold the stencils interchangeably; then walked around Fishers Island taking photographs through the stencils. The first photograph in the sequence was made by releasing (and later re-collecting) the painted gouache cutouts into the Atlantic, and photographing their movements.

This work was made possible by the generous support of a The Lighthouse Works fellowship and a Minnesota Emerging Writer's grant from The Loft Literary Center and The Jerome Foundation.

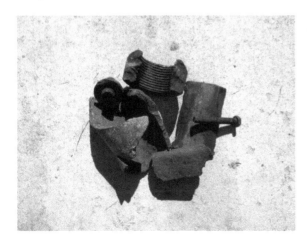

rust – I based these mixed-media gouache drawings on select objects from my rust collection. (Minneapolis, MN 2015)

Thank you to visual art faculty Christine Baeumler and my classmates in her art theory course, for their support of the first draft of this piece.

<u>Two voices discuss the merits of writing about pain</u> – This poem emerged out of my first reading of *Falling Out of Time* by David Grossman, translated from the Hebrew by Jessica Cohen (Alfred A. Knopf, New York 2014). The left-aligned lines on p.109-110, which appear below in bold, are borrowed from dialog spoken by The Centaur, a character who attempts to come to terms with the death of his child through writing. He addresses his speech to the Town Chronicler (quoted material indicated in bold within its original context):

> **"But if I don't write it I won't understand."** [77]

> "Well then, write this, please, in big letters, giant ones: *I must re-create it in the form of a story!* Do you get that?" [78]

> **"That's the only way I can somehow get close to it**, to that goddamn *it*, without it killing me, you know? **I have to dance around in front of it, I have to move, not freeze like a mouse who sees a snake.** I have to feel, even just for a minute, just half a second, the last free place I may still have inside me, the fraction of a spark that still somehow glows inside, which that lousy it couldn't extinguish. **Ugh! I have no other way. You have to get that:** *I have no other way.* And maybe there is no other way, huh? I don't know, and you wouldn't understand, so at least write it down, quick: **I want to knead it—yes,** *it,* **the thing that happened, the thing that struck like lightning and burned everything I had,** including the words, goddamn it and its memory, the bastard burned the words that could have described it for me. And I have to mix it up with some part of me." [79]

<u>Arranging Nets for Mending</u> – This piece is a cycle of centos. A cento is a poetic form in which found text of various origins (literature, music, reference, etc) is fragmented and collaged together to create a new text. In these centos, I used the following sources: *Through A Glass Darkly*, Ingmar Bergman film, 1961; "My Body is a Cage," Arcade Fire song, 2007; "Net mending and patching," fishing net repair manual by P. D. Lorimer, 1978; "Littoral Zone," Britannica.com encyclopedia entry, 2017.

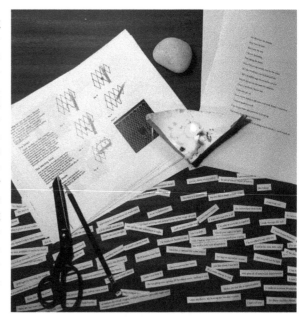

For this piece I printed all of my source texts, cut out small phrases, and moved words and phrases around until I settled on these arrangements. The various sources are woven together throughout each segment and line, sometimes only two or three words at a time; spaces and line breaks do not necessarily align with a switch between sources.

Special thanks to generous friend and artist Jared Buckheister for introducing me to *Through A Glass Darkly*, and to The Lighthouse Works where I had the space and time to create this piece.

<u>The Condition of Being</u> – Thank you, Body, for being.

Anne Carson's "The Glass Essay" (New Directions, 1994; poem available at poetryfoundation. org) had a powerful influence on this collection before any of these pieces came into being; Carson's Nudes from "The Glass Essay" were an unconscious reference point for some of the imagery and feeling tone echoes in my poem, especially Carson's closing lines:

"…as I came closer / I saw it was a human body // trying to stand against winds so terrible that the flesh was blowing off the bones. / And there was no pain. / The wind // was cleansing the bones. / They stood forth silver and necessary. / It was not my body, not a woman's body, it was the body of us all. / It walked out of the light." [poetryfoundation.org]

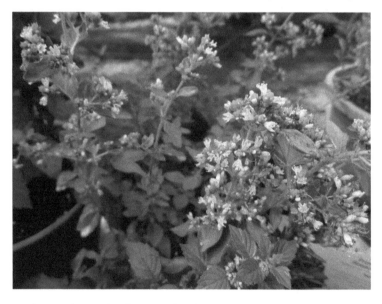

<u>Meet Me in the Garden</u> – Thank you to the plants and growing things I've had relationships with throughout the creation of this work, especially the flowers, herbs, and vegetables in my summer garden that got me through the final stages of revision.

Thanks also to Simone Muench and the editors at *Jet Fuel Review* for giving this poem a home in your publication.

[gratitudes]

To Roy G. Guzmán for your friendship, supportive feedback, shared celebration, and creative companionship since the first moment we met in digital space, but especially for lighting the way as we walked side by side into the forest of our first books and tried to find our way back out again; to grey doolin for your love and support through the evolution of this project from the first word to the last, and the countless hours you spent talking with me about this work and reading versions of these pieces; to kiki kosnick for creating the community that brought us all together and in which this project first began, and for always being my champion; to Niko Tsocanos for the thread that weaves in and out of these pieces; to Marcelle Richards, my favorite cactus cowboy co-pilot on this plane and beyond; to Carise and Barbara for seeing me through the work behind this work; to Aubrie Cox and Isaac Kirkman for your vital words and for knowing what it's like; to Hannah Sabri Barco and Andrew Barco for teaching me the true meaning of collaboration; to Mom, Dad, Peter, Laura and the Palmaros, aunt Marilyn, the Alarcon-Allens, and my extended family for your support and encouragement; to Admiral Wieland, Yasmiene Mabrouk, Beth Ellsworth, Su Hwang, Jonathan Damery, Rachel Wingo, Kate Ritter, Marisa Prefer, Jesselyn Dreeszen-Bowman, Morgan Meyer, Jordan Schuster, and my friends, beloveds, chosen fam, and lovers past/present/future who live all over the map but are always in my heart.

To Elæ [Lynne DeSilva-Johnson] for believing in this book, and for your labor and creative genius as the heart of The Operating System.

To mentors V.V. Ganeshananthan, Sun Yung Shin, Ray Gonzalez, and Roy G. Guzmán for your invaluable insights and guidance on numerous versions of this work; to Nicole Oquendo for your valuable feedback on the manuscript in 2017, which guided my final revisions; to Holly Vanderhaar for all of your work both in front of and behind the scenes of the MFA program; to the other teachers who have influenced my creative development in regards to this book, including Kim Todd, Julie Schumacher, Diane Willow, Simone Muench, Anna Journey, Christine Baeumler, Mark Doty, Christopher Miller, Mark Wunderlich, Betsy Sherman, Sarah Pike, Mary Lum, Ann Pibal, and Peggy Florin; and last but never least, to the original mentor-hero #NancyDuffnerForever.

To the many ecosystems that have supported me and my creative work throughout the process of making this book, including The Operating System; my multidisciplinary poet-artist-activist network in Minneapolis; my cohort, classmates, staff and faculty at the University of Minnesota Creative Writing MFA & Visual Art MFA; my residency family at The Lighthouse Works (Tryn, Nate, Jared, Leah, Zach, Kate) and everyone at Fishers Island for welcoming us; the 20% Theatre Company ecosystem, especially the 2016 Naked I cast and crew; my classmates in Diane Willow's Interdisciplinary Collaboration course; our little

armadillo writer crew at the Atlantic Center for the Arts; everyone in the LGBTQ Narratives family at OutReach Community Center in Madison; the Avalon Co-op crew; my Bennington community near and far; and to the other multidisciplinary poets, disabled artists-activists-humans, and queer and trans folx whose lives and work make me and mine possible.

To the residencies, grants, and fellowships that provided time and space to create this body of work, including The Lighthouse Works; Atlantic Center for the Arts; the Andrews Forest Artist Residency; Write On, Door County!; The Minnesota Emerging Writers' Grant from The Loft Literary Center and The Jerome Foundation; the Michael Dennis Browne Fellowship and the College of Liberal Arts Grant from University of Minnesota; the Atlantic Center for the Arts and The Pabst Foundation; and everyone who supported my two crowdfunding campaigns in 2013-14, allowing me to attend my first residency and do a self-directed residency before graduate school, during which I wrote the earliest drafts of some of the pieces that appear in this book.

To the publications in which versions of these pieces appeared: Manticore: Hybrid Writing for Hybrid Identities, Jet Fuel Review, Lockjaw Magazine, Poetry City USA, District Lit, pnk prl, Connotation Press, Black Warrior Review, cream city review, Rogue Agent, and QDA: A Queer Disability Anthology.

And, finally, to the many poet-artists whose hybrid texts showed me the way, including *Bright Felon*, Kazim Ali; *The Hemophiliac's Motorcycle,* Tom Andrews; *Deep Salt Water*, Marianne Apostolides; *Tender Points*, Amy Berkowitz; *Nox*, Anne Carson; *Recombinant*, Ching-In Chen; *Brilliant Imperfection*, Eli Clare; *Waveform*, Amber DiPietra & Denise Leto; *Black Lavender Milk*, Angel Dominguez; *Fire to Fire*, Mark Doty; *Electric Arches*, Eve L. Ewing; *Avant Gauze,* Christine Friedlander; *Young Tambling*, Kate Greenstreet; *Falling Out of Time*, David Grossman transl. Jessica Cohen; *A Bestiary*, Lily Hoang; *Patient*, Bettina Judd; *Humanimal: A Project for Future Children*; Bhanu Kapil; *what the werewolf told them / lo que les dijo el licántropo*, Chely Lima transl. Margaret Randall; *Love, An Index,* Rebecca Lindenberg; *The Somnambulist*, Lara Mimosa Montes; *Irradiated Cities*, Mariko Nagai; *Something Bright, Then Holes*, Maggie Nelson; *The Ground I Stand on Is Not My Ground*, Collier Nogues; *Silent Anatomies*, Monica Ong; *Citizen*, Claudia Rankine; *Dandarians*, Lee Ann Roripaugh; *Unbearable Splendor*, Sun Yung Shin; *Visceral Poetics*, Eleni Stecopoulos; *The Amputee's Guide to Sex,* Jillian Weise; *Written on the Body*, Jeanette Winterson; *Alchemy for Cells & Other Beasts*, Maya Jewell Zeller and Carrie DeBacker; and the anthologies *Beauty is a Verb: The New Poetry of Disability*, Cinco Puntos Press and *Family Resemblance: An Anthology and Exploration of 8 Hybrid Literary Genres*, Rose Metal Press.

[image index - by page number]

Greetings comrade! Thank you for talking to us about your process today!
Can you introduce yourself, in a way that you would choose?

Thank you for talking with me! My name is D., I use they/them pronouns, and I'm a multidisciplinary poet and artist. I identify as queer, genderqueer/nonbinary, and disabled; I was diagnosed with Ehlers-Danlos Syndrome (EDS) in my mid-twenties. I'm now based in Minneapolis, MN, but I was born and raised north of Durham, NC, and have strong ties to southern Vermont and Madison, WI.

Why are you a poet/writer/artist/creator?

Poetry is my calling. I have chosen poetry over and over again when I could have turned away, but poetry made the first move. That original why remains a mystery.

When did you decide you were a poet/writer/artist (and/or: do you feel comfortable calling yourself a poet/writer/artist, what other titles or affiliations do you prefer/feel are more accurate)?

I have been writing poems and making art since I was small, but like many of us it took me a while to figure out when/how/if I was allowed to call myself a poet-artist. I've gone through periods where those words felt right and easy, followed by times where I wasn't sure I could or should use them. Sometimes my resistance to calling myself a poet-artist has been because I felt like an imposter, especially when I compared myself to others who seemed to be doing more/better/faster. These days, even when I feel confident in myself and my work, I still try to ask when, why, and with what intentions I use specific titles for myself; I don't want to participate in that sticky art/lit-world hierarchy that deems some creators worthy of titles like "poet" and others unworthy. All of us are capable of wielding our titles as weapons to exclude others from what we consider our territory. We are equally capable of using our self-determined identities to model inclusion and access; I now call myself a poet-artist in nearly every situation, and I mean it to be a door held open for anyone who might be listening nearby, unsure of whether they're allowed to walk through.

For the past couple of years I've settled on calling myself a multidisciplinary poet-artist, but if I have to choose one I just say poet. Though I work in many mediums, "poet" feels like an umbrella identity that not only refers to what I make, but also to my methods, intentions, intuitions, and the relational approach I bring to my work.

What's a "poet" (or "writer" or "artist") anyway? What do you see as your cultural and social role (in the literary / artistic / creative community and beyond)?

As a poet, everything is my job. Poetry allows and requires me to be open, pay attention, connect, reflect, respond, transform, and participate in public life while

remaining attuned to my inner life. Poetry, for me, is inherently relational and involves more than words. I feel most like a poet when I'm baking bread to share with my people, or when a friend and I take turns going to each other's doctor's appointments. It's true, I'm an introvert with a very slow artistic process; I do need substantial alone time to create my work, but my process would be nothing without the conversations, collaborations, and human exchanges I have daily within my communities.

Talk about the process or instinct to move these poems (or your work in general) as independent entities into a body of work. How and why did this happen? What encouraged and/or confounded this (or a book, in general) coming together? Did you envision this collection as a collection or understand your process as writing or making specifically around a theme while the poems themselves were being written / the work was being made?

All of the text within these pages emerged in 2014-2017, but this project began in 2012 as a handful of poems that I wrote in response to my new EDS diagnosis. Those early poems were mostly for me; I needed a container for my grief and frustration, and I also wanted to try to reconcile my expansive, queer, vibrant desires with chronic pain, injury, and fatigue. I could first make out the silhouette of a book when I had amassed enough individual poems that were thematically and narratively related, but as much as I tried, they never quite lit up when I placed them side by side. I then decided to let go of the rigid conceptual structure I'd planned—originally, each bone in the human body was going to correspond to one poem or section of a poem—and experiment more with form, genre, and image. The book became a single continuous text rather than a collection of parts. I found wholeness through hybridity. The work came together more easily after that. I found myself lovingly taking the early poems out one by one until none were left. The first dictionary erasure poem I did, "needle," led me to create the visual, object-based lyric essays at the center of the book, and the other pieces arranged themselves into the first and last sections accordingly. I had so much generous support and guidance along the way. The book absolutely would not be what it is without my community.

What formal structures or other constrictive practices (if any) do you use in the creation of your work? Have certain teachers or instructive environments, or readings/writings/ work of other creative people informed the way you work/write?

I'll often generate initial drafts without imposing any constrictive practices or formal structures on the work. Once I get a sense for what the piece wants to say, I will experiment with form and media from there. Many times, I won't even write down the earliest of early drafts, but will keep phrases and concepts rolling around in my mind until clearer shapes emerge from that primordial soup. That said, I often make centos, erasures, detail-oriented visual work, and collages when I'm stuck or feeling restless, or I'll find something to respond to, like an artwork or a specific place. I also have a collection of dictionaries and other reference books that I mine frequently for ideas.

My work is informed by too many texts, people, and ecosystems to name here, so I've paid tribute to them in my *Process Notes* and *Gratitudes* sections.

Speaking of monikers, what does your title represent? How was it generated? Talk about the way you titled the book, and how your process of naming (individual pieces, sections, etc) influences you and/or colors your work specifically.

I really struggle with titles, so I typically use placeholders for a long time. I called the collection *Connective Tissue* for the first several years, but when the project's hybrid identity emerged, that no longer fit. In a later stage of revision, I was flipping through the text looking for possible title ideas (at the suggestion of my MFA cohort) when the phrases "bony framework" and "tangible universe"—from the dictionary erasure poems "body" and "material"—caught my attention. I squinted my eyes, trusted my instincts, and *A Bony Framework for the Tangible Universe* came into being. Titling some of the individual poems by their first lines also felt right after years of using boring placeholder titles, as did letting the dictionary erasure poems serve as titles for the pieces in the middle section of the book. Sometimes it's best to recognize your weaknesses and lean in instead of trying to cover them up.

What does this particular work represent to you as indicative of your method/creative practice? history? mission/intentions/hopes/plans?

This is my first book. It emerged from immediate grief, expanded into memory, became a love letter, and now holds all of these truths simultaneously. Whether I'm creating text objects, visual work, stage performances, or other media, I intend to keep following my work across lines of discipline and genre—and always listen to the body.

What does this book DO (as much as what it says or contains)?

This book casts a spell for:

repair
metamorphosis
adaptation
witnessing
desire
memory
resourcefulness
vibrancy
resilience
nurturance
allowing
collectivity

SPELL DIAGRAM

What would be the best possible outcome for this book? What might it do in the world, and how will its presence as an object facilitate your creative role in your community and beyond? What are your hopes for this book, and for your practice?

A Bony Framework for the Tangible Universe came out of my networks, relationships, connections, ecosystems—the book is my gesture of giving back to those systems, and I hope that intention translates. My illness has changed (is changing) the ways in which I'm able to physically engage in both public and intimate spaces, so my dream is that the book will now go out into the world to build its own relationships and communities, whether or not I, the creator, am involved. I want the book to find its way into the hands of people who need it—especially queer and trans folks with disabilities, people with EDS who don't find their experiences reflected in many places, those dealing with body grief, other artists whose work doesn't fit neatly into categories, and anyone who has loved.

If I'm lucky, one reader might bury the book in their garden to see what grows.

Let's talk a little bit about the role of poetics and creative community in social activism. I'd be curious to hear some thoughts on the challenges we face in speaking and publishing across lines of race, age, privilege, social/cultural background, and sexuality within the community, vs. the dangers of remaining and producing in isolated "silos."

First, I want to say that I'm responding to this as a queer, genderqueer, disabled artist with US citizenship, white privilege, current access to healthcare, and a robust support network. That said, I want to make the distinction between silos and havens: the former is a stale echo chamber where innovation cannot thrive, while the latter is a nurturing community space that we can move in and out of to recharge. When presenting public work, many artists with marginalized identities are already constantly engaging across lines of difference, intentionally or not. This can create surprising, generative connections and deepen our artistic practice. It can also put artists at risk of burnout, microaggressions, violence, diminishment, tokenism, and more.

When I was newly out as queer, I joined LGBTQ Narratives, an activist-writer's group in Madison, WI, founded by bighearted activist and scholar kiki kosnick. During my three years in the community, Narratives was intergenerational and identity-inclusive; we met every other week and also created a monthly open-mic, a monologues play, and other community projects. At the time, someone in my life asked, "Why do you have to be a queer writer? Why can't you just be a writer?" I didn't know how to respond in the moment, but now the answer seems simple: I needed to hold and be held within a specifically queer space in order to strengthen my writing practice and rebuild my resilience. Narratives was essential not only for my artistic development, but for my literal survival. I found members of my chosen family in that space. I found my voice after losing track of it in a thicket of depression,

harassment, illness, rejection, and loss. Even now, when I live in a different city and haven't attended a Narratives meeting in years, I hold that community within myself and try to bring its values everywhere I go. Especially for writer-artist-humans of marginalized groups, it's essential to have access to community spaces like Narratives, while also continuing to exchange work and ideas across identity lines.

Is there anything else we should have asked, or that you want to share?

This project is relational, and it's yours now. Thank you for being here.

Photo credit: Roy G. Guzmán

D. ALLEN is a queer poet and multidisciplinary artist whose work often examines gender, intimacy, disability/illness, and the natural world. Their work takes many forms: word architectures, painted surfaces, light drawings, textured sounds, soft spaces, slow dinners, sustained listening, tender assemblages, quiet gardening, deep breaths. They value each of these endeavors equally. D. earned an MFA from The University of Minnesota, and has received a 20% Theatre Company Q-STAGE Fellowship, a VSA Minnesota Emerging Artist Grant, a Minnesota State Arts Board Artist Initiative Grant, a Minnesota Emerging Writers' Grant from The Loft Literary Center, and a Michael Dennis Browne Fellowship. They have been an artist in residence at Mallard Island, The Lighthouse Works, Write on Door County, the H.J. Andrews Experimental Research Forest, and The Atlantic Center for the Arts. *A Bony Framework for the Tangible Universe* is D.'s first book.

Instagram: @thebodyconnected
Website: thebodyconnected.com

a KIN(D)* TEXTS & PROJECTS publication

The Operating System has always understood itself as a queer press: not only insofar as that it was founded, consistently produces work by, and is staffed by primarily queer creative practitioners, but also in its commitment to *queering* the normative forms and expectation of that practice. If to queer something is to "take a look at its foundations and question them," troubling its limits, biases, and boundaries, seeking possibilities for evolution and transformation, then queering is written into the DNA of the Operating System's mission in every action and project, regardless of the orientation or gender of its maker.

However: while all the publications and projects we support encourage radical divergence and innovation, we are equally dedicated to recentering the canon through committing parts of our catalog to amplifying those most in danger of erasure. First, this took to the form of our translation and archival oriented *Glossarium: Unsilenced Texts* series, started in 2016, and in 2018 we made concrete our already active mission to work with creators challenging gender normativity with our *KIN(D)* Texts & Projects* series. Projects and publications under the *KIN(D)* moniker are those developed by creators who are transgender, nonbinary, genderqueer, androgynous, third gender, agender, intersex, bigender, hijra, two-spirit, and/or whose gender identity refuses a label.

Titles in this series through 2019 include:

A Bony Framework for the Tangible Universe - D. Allen
Opera on TV - James Brunton
Hall of Waters - Berry Grass
Transitional Object - Adrian Silbernagel
Sharing Plastic - Blake Neme
The Ways of the Monster - Jay Besemer
Marys of the Sea - Joanna C. Valente
lo que les dijo el licantropo / what the werewolf told them - Chely Lima
Greater Grave - Jacq Greyja
cyclorama - Davy Knittle

WHY PRINT / DOCUMENT?

The Operating System uses the language "print document" to differentiate from the book-object as part of our mission to distinguish the act of documentation-in-book-FORM from the act of publishing as a backwards-facing replication of the book's agentive *role* as it may have appeared the last several centuries of its history. Ultimately, I approach the book as TECHNOLOGY: one of a variety of printed documents (in this case, bound) that humans have invented and in turn used to archive and disseminate ideas, beliefs, stories, and other evidence of production.

Ownership and use of printing presses and access to (or restriction of printed materials) has long been a site of struggle, related in many ways to revolutionary activity and the fight for civil rights and free speech all over the world. While (in many countries) the contemporary quotidian landscape has indeed drastically shifted in its access to platforms for sharing information and in the widespread ability to "publish" digitally, even with extremely limited resources, the importance of publication on physical media has not diminished. In fact, this may be the most critical time in recent history for activist groups, artists, and others to insist upon learning, establishing, and encouraging personal and community documentation practices. Hear me out.

With The OS's print endeavors I wanted to open up a conversation about this: the ultimately radical, transgressive act of creating PRINT /DOCUMENTATION in the digital age. It's a question of the archive, and of history: who gets to tell the story, and what evidence of our life, our behaviors, our experiences are we leaving behind? We can know little to nothing about the future into which we're leaving an unprecedentedly digital document trail — but we can be assured that publications, government agencies, museums, schools, and other institutional powers that be will continue to leave BOTH a digital and print version of their production for the official record. Will we?

As a (rogue) anthropologist and long time academic, I can easily pull up many accounts about how lives, behaviors, experiences — how THE STORY of a time or place — was pieced together using the deep study of correspondence, notebooks, and other physical documents which are no longer the norm in many lives and practices. As we move our creative behaviors towards digital note taking, and even audio and video, what can we predict about future technology that is in any way assuring that our stories will be accurately told – or told at all? How will we leave these things for the record?

In these documents we say:
WE WERE HERE, WE EXISTED, WE HAVE A DIFFERENT STORY

- Elæ [Lynne DeSilva-Johnson], Founder/Creative Director
THE OPERATING SYSTEM, Brooklyn NY 2018

RECENT & FORTHCOMING FULL LENGTH
OS PRINT::DOCUMENTS and PROJECTS, 2018-19

2019

Ark Hive - Marthe Reed
I Made for You a New Machine and All it Does is Hope - Richard Lucyshyn
Illusory Borders - Heidi Reszies
A Year of Misreading the Wildcats - Orchid Tierney
We Are Never The Victims - Timothy DuWhite
Of Color: Poets' Ways of Making | An Anthology of Essays on Transformative Poetics -
Amanda Galvan Huynh & Luisa A. Igloria, Editors
The Suitcase Tree - Filip Marinovich
In Corpore Sano: Creative Practice and the Challenged* Body - Elae [Lynne DeSilva-
Johnson] and Amanda Glassman, Editors

KIN(D)* TEXTS AND PROJECTS

A Bony Framework for the Tangible Universe - D. Allen
Opera on TV - James Brunton
Hall of Waters - Berry Grass
Transitional Object - Adrian Silbernagel

GLOSSARIUM: UNSILENCED TEXTS AND TRANSLATIONS

Śnienie / Dreaming - Marta Zelwan, (Poland, trans. Victoria Miluch)
Alparegho: Pareil-À-Rien / Alparegho, Like Nothing Else - Hélène Sanguinetti
(France, trans. Ann Cefola)
High Tide Of The Eyes - Bijan Elahi (Farsi-English/dual-language)
trans. Rebecca Ruth Gould and Kayvan Tahmasebian
In the Drying Shed of Souls: Poetry from Cuba's Generation Zero
Katherine Hedeen and Víctor Rodríguez Núñez, translators/editors
Street Gloss - Brent Armendinger with translations for Alejandro Méndez, Mercedes
Roffé, Fabián Casas, Diana Bellessi, and Néstor Perlongher (Argentina)
Operation on a Malignant Body - Sergio Loo (Mexico, trans. Will Stockton)
Are There Copper Pipes in Heaven - Katrin Ottarsdóttir
(Faroe Islands, trans. Matthew Landrum)

2018

An Absence So Great and Spontaneous It Is Evidence of Light - Anne Gorrick
The Book of Everyday Instruction - Chloë Bass
Executive Orders Vol. II - a collaboration with the Organism for Poetic Research
One More Revolution - Andrea Mazzariello
Chlorosis - Michael Flatt and Derrick Mund
Sussuros a Mi Padre - Erick Sáenz
Abandoners - Lesley Ann Wheeler
Jazzercise is a Language - Gabriel Ojeda-Sague
Born Again - Ivy Johnson
Attendance - Rocío Carlos and Rachel McLeod Kaminer
Singing for Nothing - Wally Swist
Walking Away From Explosions in Slow Motion - Gregory Crosby
Field Guide to Autobiography - Melissa Eleftherion

KIN(D)* TEXTS AND PROJECTS

Sharing Plastic - Blake Neme
The Ways of the Monster - Jay Besemer

GLOSSARIUM: UNSILENCED TEXTS AND TRANSLATIONS

The Book of Sounds - Mehdi Navid (Farsi dual language, trans. Tina Rahimi
Kawsay: The Flame of the Jungle - María Vázquez Valdez (Mexico, trans. Margaret Randall)
Return Trip / Viaje Al Regreso - Israel Dominguez; (Cuba, trans. Margaret Randall)

for our full catalog please visit:
https://squareup.com/store/the-operating-system/

deeply discounted Book of the Month and Chapbook Series subscriptions
are a great way to support the OS's projects and publications!
sign up at: http://www.theoperatingsystem.org/subscribe-join/

DOC U MENT

/däkyəmənt/

First meant "instruction" or "evidence," whether written or not.

noun - a piece of written, printed, or electronic matter that provides information or evidence or that serves as an official record
verb - record (something) in written, photographic, or other form
synonyms - paper - deed - record - writing - act - instrument

[*Middle English, precept, from Old French, from Latin documentum, example, proof, from docre, to teach; see dek- in Indo-European roots.*]

Who is responsible for the manufacture of value?

Based on what supercilious ontology have we landed in a space where we vie against other creative people in vain pursuit of the fleeting credibilities of the scarcity economy, rather than freely collaborating and sharing openly with each other in ecstatic celebration of MAKING?

While we understand and acknowledge the economic pressures and fear-mongering that threatens to dominate and crush the creative impulse, we also believe that
now more than ever we have the tools to relinquish agency via cooperative means,
fueled by the fires of the Open Source Movement.

Looking out across the invisible vistas of that rhizomatic parallel country
we can begin to see our community beyond constraints, in the place where intention meets resilient, proactive, collaborative organization.

Here is a document born of that belief, sown purely of imagination and will.
When we document we assert. We print to make real, to reify our being there.
When we do so with mindful intention to address our process, to open our work
to others, to create beauty in words in space, to respect and acknowledge the strength
of the page we now hold physical, a thing in our hand, we remind ourselves that,
like Dorothy: *we had the power all along, my dears.*

THE PRINT! DOCUMENT SERIES

is a project of
the trouble with bartleby
in collaboration with
the operating system

CPSIA information can be obtained
at www.ICGtesting.com
Printed in the USA
BVHW061107050319
541786BV00002B/27/P